BOTHERED BY
MY GREEN CONSCIENCE

How an SUV-driving, imported-strawberry-eating urban dweller can go green

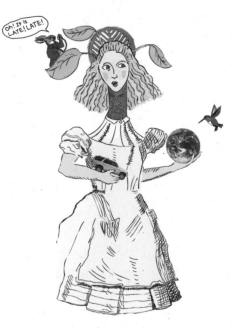

Franke James

NEW SOCIETY PUBLISHERS

Cataloging in Publication Data:
A catalog record for this publication is available from the National Library of Canada.

Copyright & Licensing Information:
Franke James' essays: My SUV and Me Say Goodbye © 2007; To My Future Grandkids in 2020 © 2007; Green Eccentric Glamour © 2008; The Real Poop on Social Change © 2008; Paradise Unpaved © 2008; Torstar Licenses: Seeding Green Driveway © Lucas Oleniuk; Rock and a Green Place © Michael Stuparyk; SuperStock, Inc. License: Conversion of St. Paul © Caravaggio;

Cover design: Franke James and Diane McIntosh.
Book design, illustrations, photography and writing by Franke James.

Printed in Canada. First printing April 2009.
Paperback ISBN: 978-0-86571-646-9

New Society Publishers acknowledges the support of the Government of Canada through the Book Publishing Industry Development Program (BPIDP) for our publishing activities.

Inquiries regarding requests to reprint all or part of *Bothered by My Green Conscience* should be addressed to New Society Publishers at the address below. To order directly, please call toll-free (North America) 1-800-567-6772 (250-247-9737 outside North America), or order online at www.newsociety.com. Any other inquiries can be directed by mail to:
New Society Publishers,
P.O. Box 189, Gabriola Island, BC V0R 1X0, Canada

NEW SOCIETY PUBLISHERS

New Society Publishers' mission is to publish books that contribute in fundamental ways to building an ecologically sustainable and just society, and to do so with the least possible impact on the environment, in a manner that models this vision. We are committed to doing this not just through education, but through action. This book is one step toward ending global deforestation and climate change. It is printed on Forest Stewardship Council-certified acid-free paper that is 100% post-consumer recycled (100% old growth forest-free), processed chlorine free, and printed with vegetable-based, low-VOC inks, with covers produced using FSC-certified stock. Additionally, New Society purchases carbon offsets based on an annual audit, operating with a carbon-neutral footprint. To browse our full list of books and purchase securely, visit our website at: www.newsociety.com.

Do you have a green conscience?

Take this little test to find out:

1. Do you feel guilty if you throw paper in the trash, instead of recycling it?

2. Do you turn off lights to save energy?

3. Do you apologize for driving a gas guzzler?

4. Do you worry about climate change?

If you answered "Yes" to any of these questions, you may be developing (or already have) a green conscience. Amazing things happened to me when I started listening to mine. This is the story of my true-life adventures in going green. I hope it will entertain you and surprise you. And possibly inspire you to "do the hardest thing first" to save the planet. If you choose to do something really neat, let me know! It might make a good story...

franke@frankejames.com

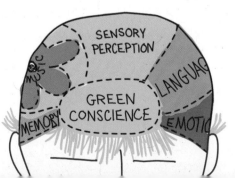

Oct 20/20[?]

Gillian,

Wonderful to
meet a fellow artist
and environmentalist!

To my mother, Patricia,

who taught me to

ISBN 978-0-86571-646-9
51695
9 780865 716469
US/CAN $16.95

reach for my dreams

and listen to my conscience.

TABLE OF CONTENTS

TABLE OF CONTENTS

To my future Grandkids in 2020

Chapter One:
My SUV and Me Say Goodbye

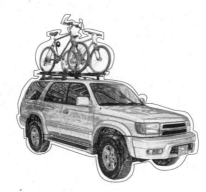

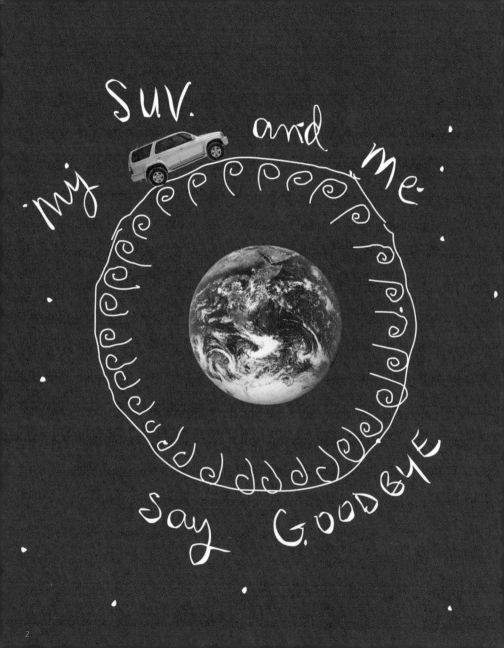

my Suv. and me.

say GOODBYE

Just as I am in the MIDDLE of a WEIGHT WORKOUT a thought POPS into my head.

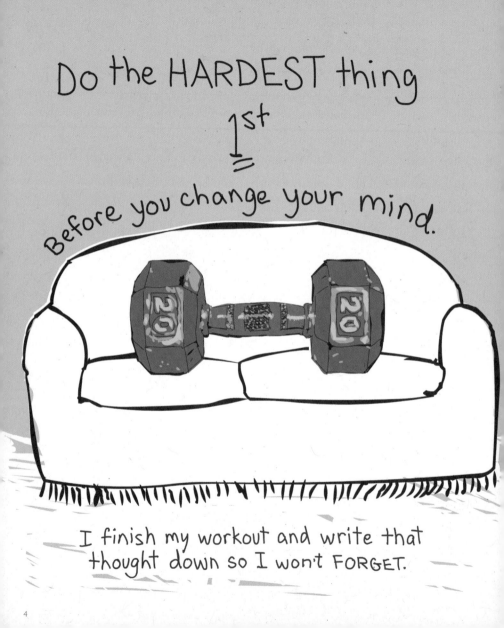

I go for a walk and think about my

I look up at the sky and WONDER about all the EXHAUST floating up↑.

I imagine the world
is a BALL wrapped up in
PLASTIC and it is
SWEATING

Like a RUNNER wearing
NON-BREATHABLE clothes.
I unzip my jacket.

I make myself brunch but I
BURN the TOAST!

I throw it out rationalizing that
we never EAT the WHOLE loaf
before it goes STALE.

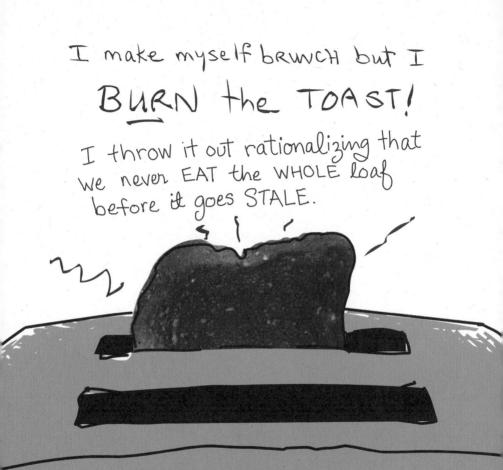

I listen to the radio announcer confirming that 2,500
scientists in Paris believe that human activity is "very
likely" to blame for Global Warming, and fossil fuel is the
main culprit.

My breakfast looks so "perfect" with the

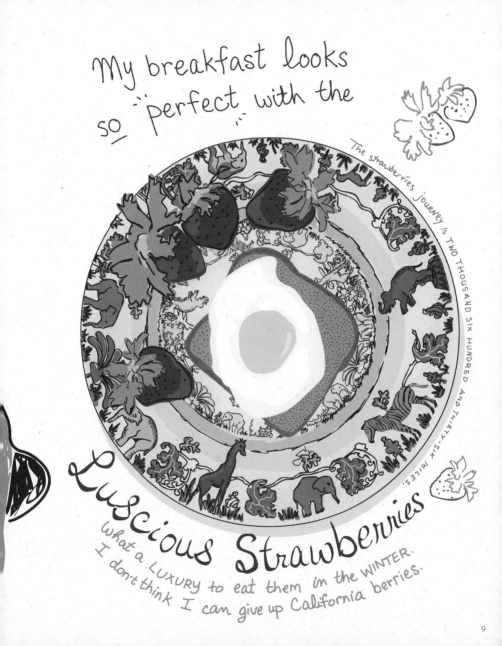

The strawberries journey is TWO THOUSAND SIX HUNDRED AND THIRTY-SIX MILES!

Luscious Strawberries

What a LUXURY to eat them in the WINTER.
I don't think I can give up California berries.

The newspaper headline shouts:

SUV SALES PLUMMET

And I think,
"Oh No! We're too LATE!"

We always talked about selling our '99 SUV.
Now the market has TURNED.

I feel SELFISH. Is it really GREEN *
to sell our old SUV if the NEW buyer
DRIVES it MORE than us?

I say to my husband,
"We have a

of OPPORTUNITY
when we can
go car-FREE.

We have a GROCERY store next door.
Our kids are older and we don't
need to drive them around.
We both LOVE to walk.
We'll save a TON of money.
AND it will be GOOD for the
environment.

IMAGINE the 🌸 we'll plant
in our EMPTY driveway.
It will be FUN.
Like when we
first got
married."

FASHION

Hair

DRY
CLEANERS

CAFE

BAGELS

FLOWERS

WINE

Suzuki is FIERCE. I think of
the "GREEN MAN" who guarded
NATURE so ferociously.

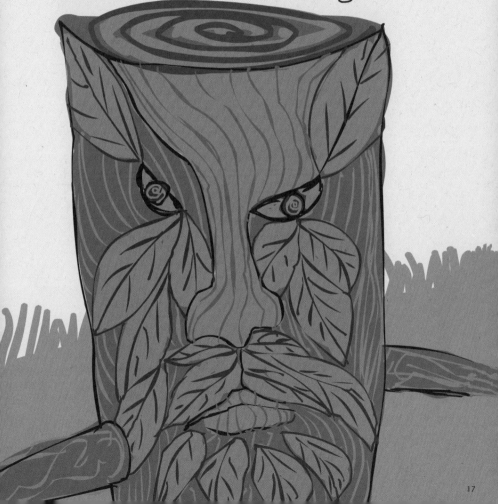

We go for an evening walk.
 It's so cold, the snow SQUEAKS!

 We make the BIG decision.
 We decide to sell the SUV.

It will be GOOD for us.

We put an AD in the paper. We get TONS of calls.
I feel NOSTALGIC for our SUV and
almost CHANGE my mind.

I tell myself...

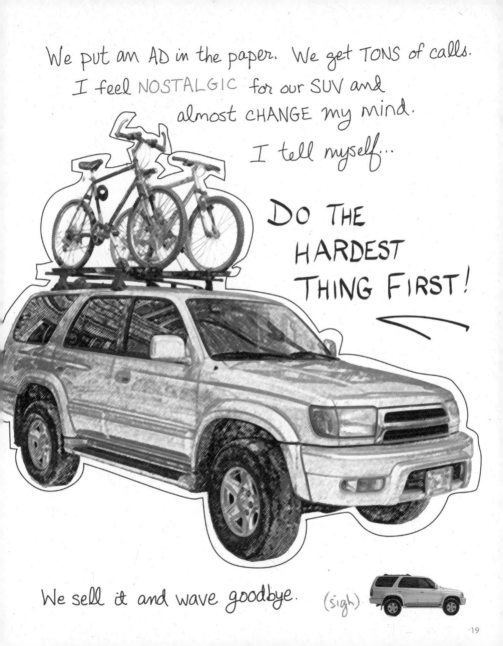

DO THE
HARDEST
THING FIRST!

We sell it and wave goodbye. (sigh)

My family reacts to our "CAR-FREE" driveway...

My daughter reacts more calmly than I expect.
"You never USED it. It was costing you money sitting in the driveway.
When are you buying a HYBRID?"

My sister-in-law blurts out, "What? ARE YOU NUTS!" But quickly recovers and says she'd love the "FREEDOM" of NO car when her kids are older.

My brother-in-law John swears, "HOLY JEEZ! You guys have gone ENVIRO! I'm down to 3 cars. You know a GAS TAX bill will be coming our way..."

My brother-in-law Larry YELLS, "YOU'RE NOT GOING TO HAVE A<u>NY</u> CAR? YOU GUYS are GRANOLA CRUNCHING, TREE HUGGING, WHACK JOBS!"

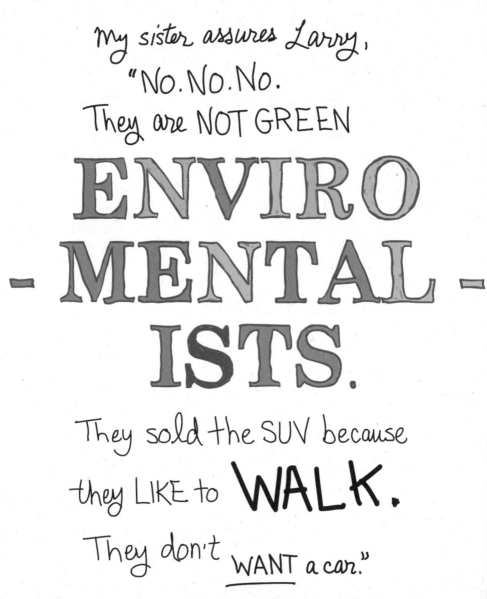

My sister assures Larry,
"No. No. No.
They are NOT GREEN

ENVIRO
- MENTAL -
ISTS.

They sold the SUV because
they LIKE to **WALK.**
They don't <u>WANT</u> a car."

Do I look like a
GREEN-HEADED
MONSTER?

I think to myself...
"GREEN IS GOOD
but I'm NOT
THAT GREEN."

I'm sure if DAVID SUZUKI
visited, he'd find LOTS of
things we do wrong.

I think of the BEER FRIDGE in the basement and all the ENERGY it's WASTING.

TONNES!

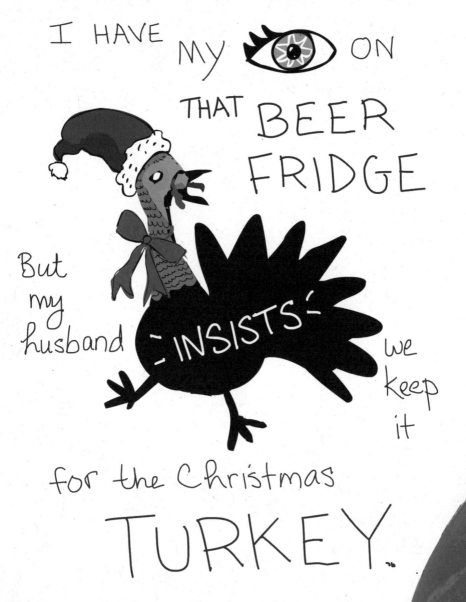

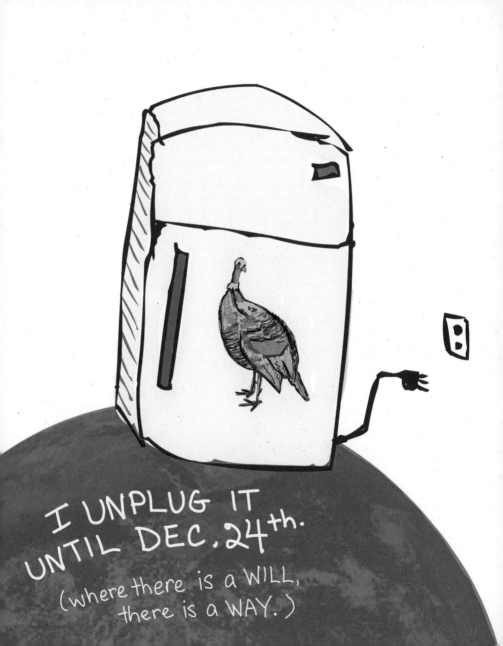

Chapter Two:
Green Eccentric Glamour

I just finished
a book
about

Eccentric
Glamour

written by
a clever wit

SIMON DOONAN
who says

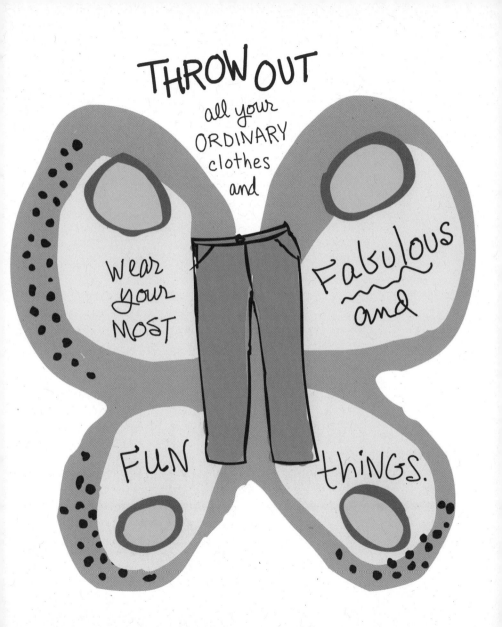

THROW OUT
all your
ORDINARY
clothes
and

wear
your
MOST

Fabulous
and

FUN

things.

I LAUGH at his
OUTRAGEOUS
idea.

And
then I DIG out
this green skirt with
ruffles.

It is light as a feather.
It is made of gauze and satin.

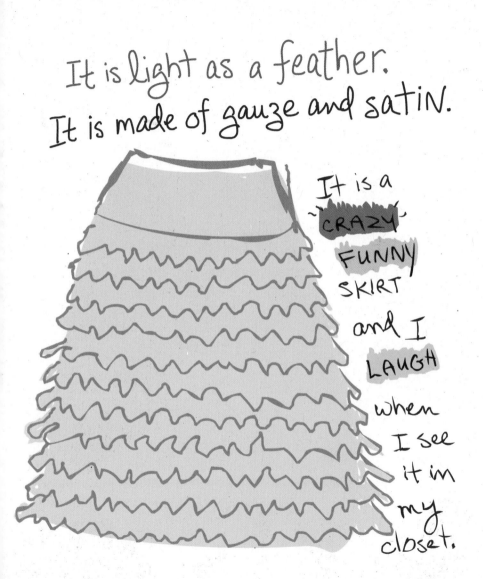

It is a
CRAZY
FUNNY
SKIRT

and I
LAUGH

when
I see
it in
my
closet.

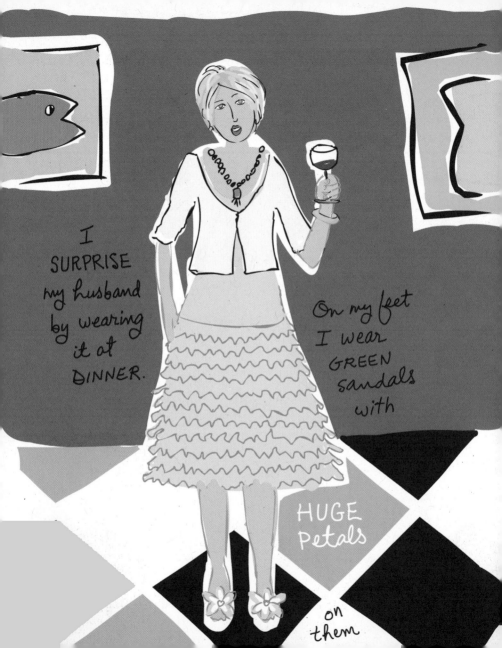

We SOLD our SUV.
And we DON'T miss it.

Maybe I don't NEED so many clothes?

Maybe this is the NEXT step in going GREEN?

Like my Eccentric

Aunt
Glady's
coat.

Ocelot coats were ALL the RAGE in her day. Now they are both DEAD.

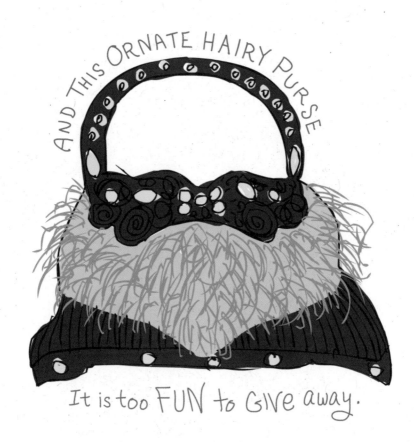

AND THIS ORNATE HAIRY PURSE

It is too FUN to GIVE away.

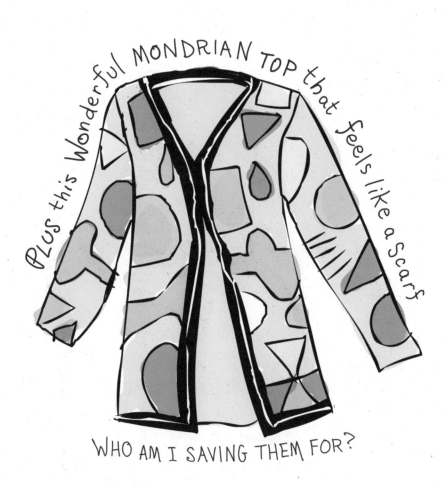

Plus this Wonderful MONDRIAN Top that feels like a Scarf

WHO AM I SAVING THEM FOR?

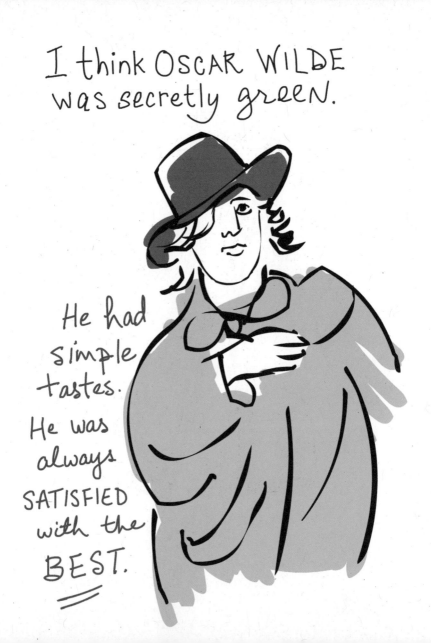

My closet
will be
SO SPARE
and
uncluttered.

And I will wear only my favorite clothes while we Raise chickens in our backyard.

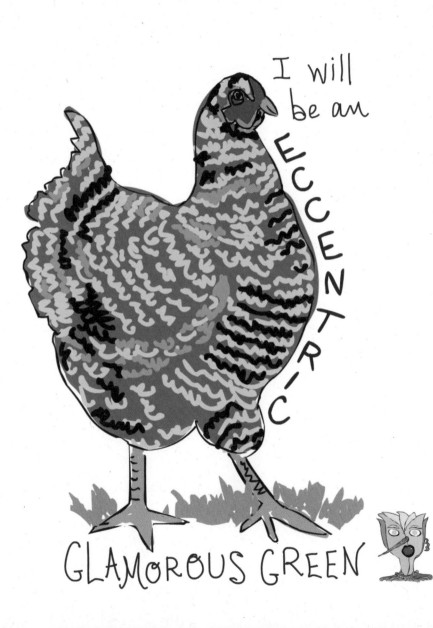

I will be an ECCENTRIC

GLAMOROUS GREEN

Chapter Three:
The Real Poop on Social Change

The
REAL POOP
on
SOCIAL
CHANGE

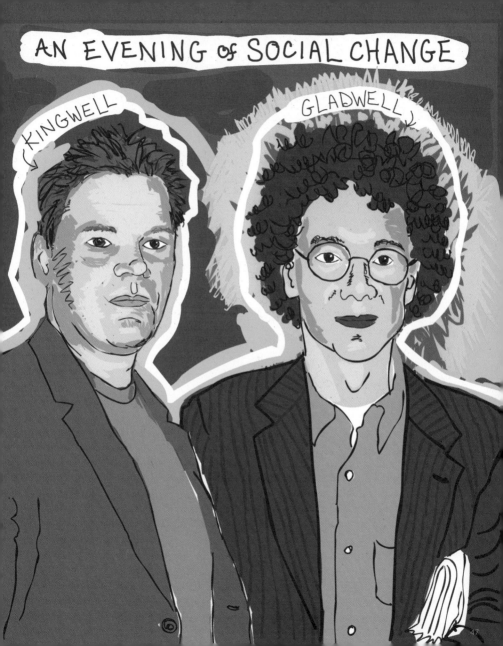

We pay $400. for 2 **VIP** tickets.

ARE WE NUTS?

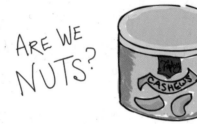

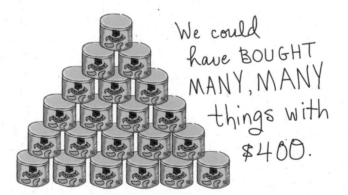

We could have BOUGHT MANY, MANY things with $400.

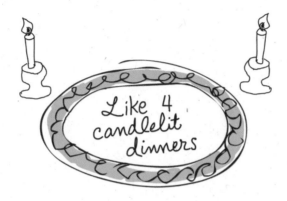

Like 4 candlelit dinners

OR NEW running shoes and walking sandals and STILL had enough left over to buy 8 HARDCOVER books.

us

We did get GOOD seats.
I REALLY wanted to hear
what GLADWELL and KINGWELL
had to say about
 changing society.

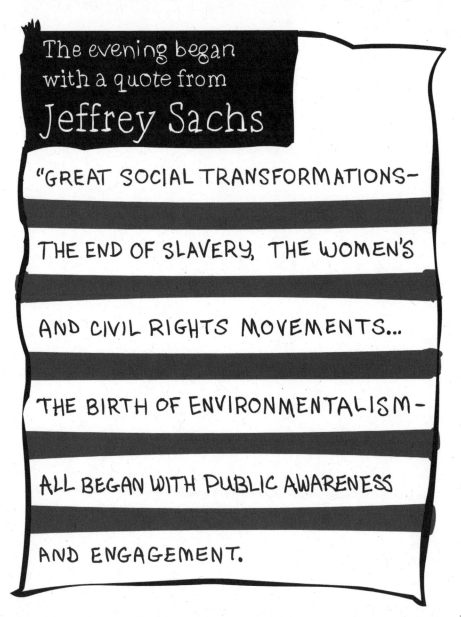

The evening began with a quote from **Jeffrey Sachs**

"GREAT SOCIAL TRANSFORMATIONS—

THE END OF SLAVERY, THE WOMEN'S

AND CIVIL RIGHTS MOVEMENTS...

THE BIRTH OF ENVIRONMENTALISM—

ALL BEGAN WITH PUBLIC AWARENESS

AND ENGAGEMENT.

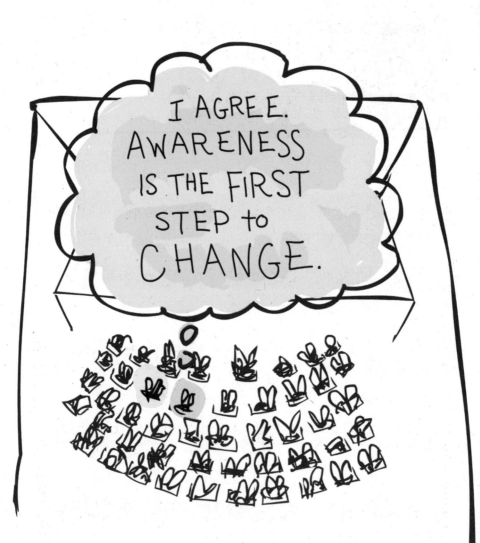

BUT THEN GLADWELL CAME ON STAGE AND SAID WE "FETISHIZE" AWARENESS

AND WHAT REALLY MATTERS IS ACTION.

HE CITED BREAST CANCER
AWARENESS CAMPAIGNS AS
AN EXAMPLE OF WASTE.

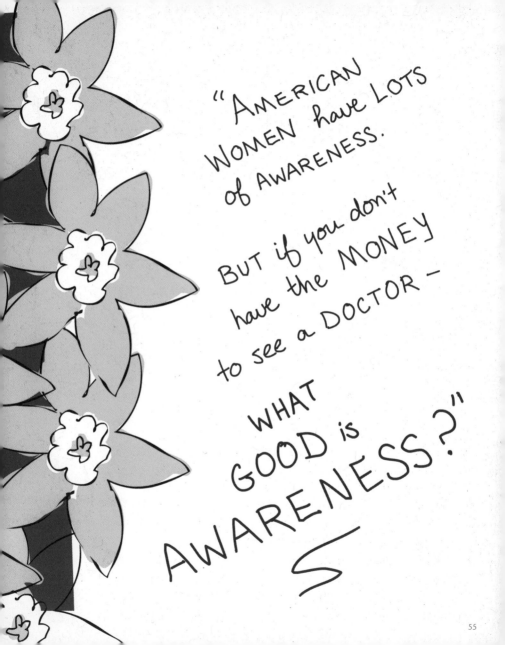

"AMERICAN WOMEN have LOTS of AWARENESS.

BUT if you don't have the MONEY to see a DOCTOR –

WHAT GOOD is AWARENESS?"

MAYBE GLADWELL IS RIGHT?
WHAT GOOD IS AWARENESS IF PEOPLE
CAN'T (or won't) FOLLOW THROUGH?

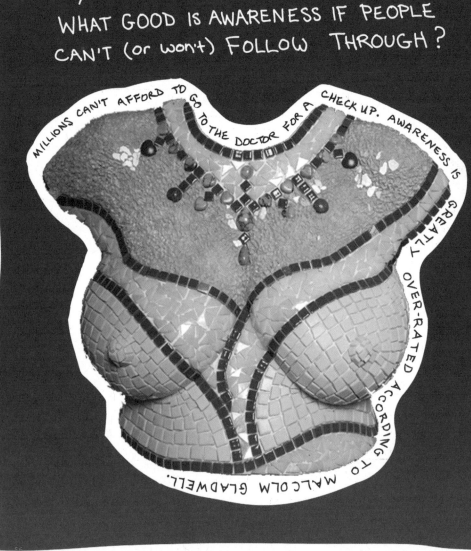

MILLIONS CAN'T AFFORD TO GO TO THE DOCTOR FOR A CHECK UP. AWARENESS IS GREATLY OVER-RATED ACCORDING TO MALCOLM GLADWELL.

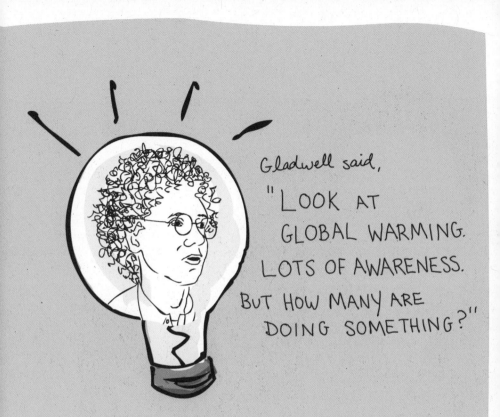

Gladwell said,

"LOOK AT
GLOBAL WARMING.
LOTS OF AWARENESS.
BUT HOW MANY ARE
DOING SOMETHING?"

I HAD TO AGREE.
LOTS OF LIGHTBULBS GETTING
CHANGED BUT NO BIG CHANGES
IN BEHAVIOR. WHAT WILL IT TAKE?

KINGWELL HAD A VERY DIFFERENT PERSPECTIVE ON SOCIAL CHANGE.

The conversion of St Paul

CARAVAGGIO

He said, "EMPATHY is the moment that makes CHANGE possible."

I DON'T KNOW...

I CAN SEE EMPATHY MAKING

PEOPLE CARE FOR VICTIMS OF CYCLONES

BUT I CAN'T SEE PEOPLE DRIVING LESS OR WALKING MORE OUT OF EMPATHY.

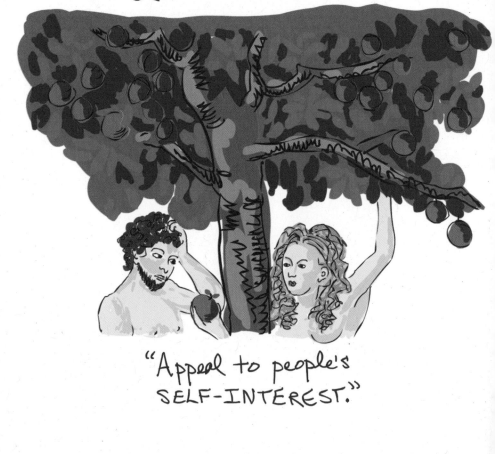

GLADWELL said, "GO AFTER the LOW HANGING FRUIT."

"Appeal to people's SELF-INTEREST."

Gladwell talked about higher costs as a DETERRENT for SMOKERS.

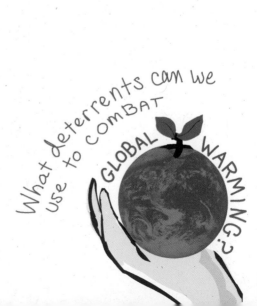

What deterrents can we use to COMBAT GLOBAL WARMING?

THERE HAVE BEEN SOME BIG BEHAVIORAL SHIFTS IN THE LAST 30 YEARS.

We all want to save face

like BANNING SMOKING*

* in many public places

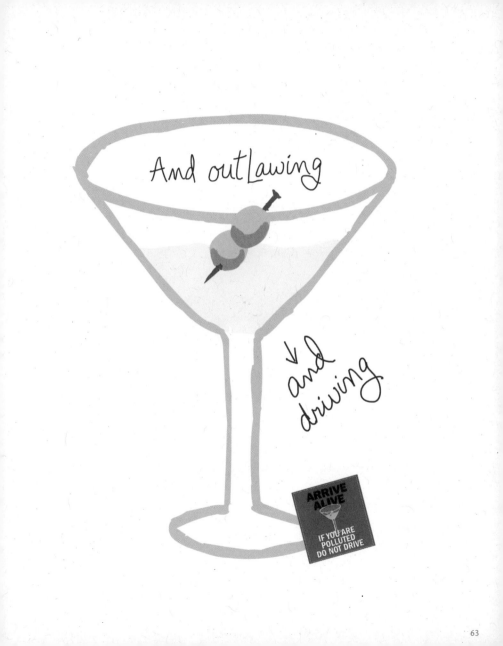

MOST PEOPLE TRY TO
AVOID BEING LABELED

THE SOCIAL LEPER

👁 THINK ABOUT DIFFERENT TYPES OF CHANGE.

THERE IS SUDDEN CHANGE. Like natural disasters and terrorist attacks. Things that come out of the ▢ .

But most SOCIAL CHANGE is <u>not</u> SUDDEN. It builds.

FROM ROOTS

CHANGE BUBBLES UP
FROM THE BOTTOM.
SOME REFUSE TO
SEE THE CHANGE → UNTIL
it gets
to the
TOP.

AND THERE IS
TOP-DOWN CHANGE
WHICH COMES IN
THE FORM OF
LAWS AND
TAXES.

MAN'S BEST FRIEND?

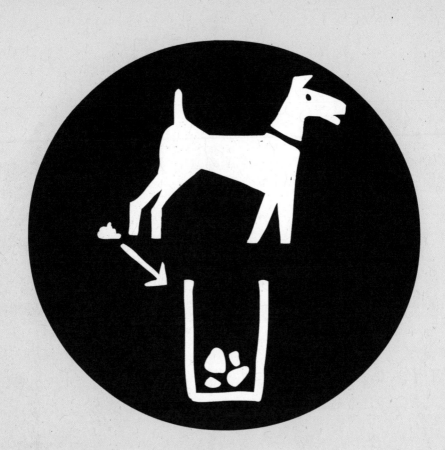

People are pretty good about
STOOPING AND SCOOPING.

NEW YORK created the POOPER SCOOPER LAW in 1978.

The THREAT of a FINE caused people to pick up.

BUT A MAJOR FACTOR WAS SOCIAL PRESSURE.

71

IS EVERYONE DOING IT?

NO.

BUT NOW IT CAUSES

SHOCK

IF A DOG OWNER FAILS
TO 'STOOP AND SCOOP'

IF PEOPLE CAN BE CONVINCED TO PICK UP DOG SHIT, WHO KNOWS WHAT SOCIAL CHANGE IS POSSIBLE?

Can Human INGENUITY
SAVE US?

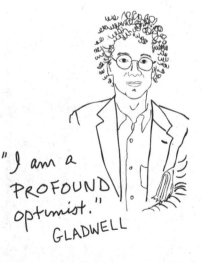

"I am a cynic, in the technical sense. I expect the worst. But hope for the best."

KINGWELL

"I am a PROFOUND optimist."

GLADWELL

And our tall host, MARK SARNER said,

"SOCIAL CHANGE IS MESSY. GOD KNOWS THERE IS A LOT TO CHANGE.

GOODNIGHT."

Was there a "lever"? $

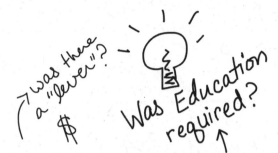

Was Education required? ↑

How did they RAISE AWARENESS? ↓

L.E.A.D.E.R.S. CHART
BY FRANKE JAMES

	No-smoking	Stoop and Scoop	Recycling
Lever (tax, fine, price)	Yes	Yes	Some cities
Education	Yes	Yes	Yes
Awareness	Yes	Yes	Yes
Doing	Yes	Yes	Yes
Empathy	No	Yes	No
Responsibility	Yes	Yes	Yes
Self-interest	Yes	Yes	Yes

MAKING POSITIVE CHANGE HAPPEN

Did people "DO" to have something? ↓

DID THEY ASK ↓ "What's in it for ME?"

Was EMPATHY key? ↓

Chapter Four:
Paradise Unpaved

PARADISE UNPAVED

I WAS CROUCHING IN THE GARDEN, LAYING IN SOME LOVELY MOIST CEDAR MULCH TO SQUELCH WEEDS,

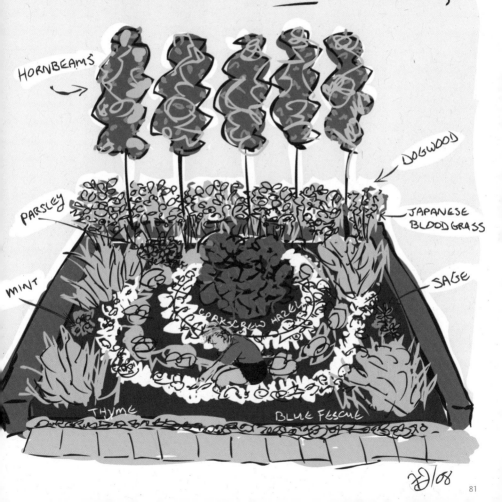

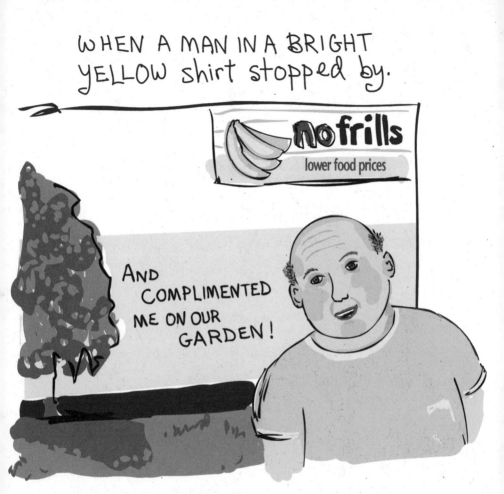

"YES! IT WAS LIKE AN EMPTY PARKING LOT! IT'S AN ASTOUNDING TRANSFORMATION!"

"ASTOUNDING!"

I WAS FLATTERED BUT...

Did our neighbors
really THINK our
driveway looked like an
empty PARKING LOT?

The man in the 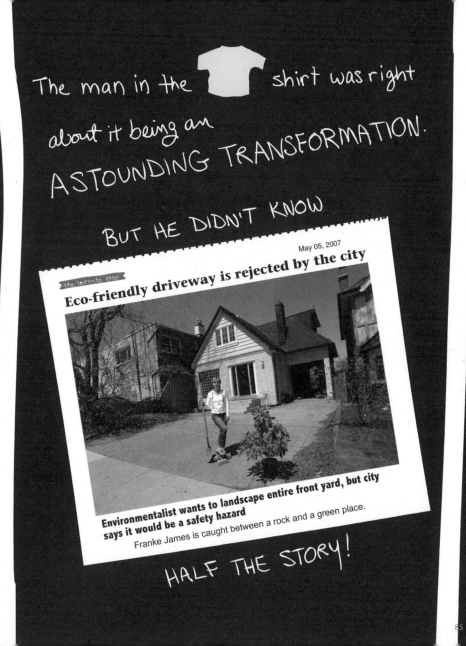 shirt was right

about it being an

ASTOUNDING TRANSFORMATION.

BUT HE DIDN'T KNOW

May 05, 2007

the toronto star

Eco-friendly driveway is rejected by the city

Environmentalist wants to landscape entire front yard, but city says it would be a safety hazard

Franke James is caught between a rock and a green place.

HALF THE STORY!

It all started when
we decided to do the

HARDEST
THING
1ST

We knew that

changing is GOOD,

But was there
SOMETHING
MORE?

SOMETHING
THAT
WOULD
REALLY
CHANGE
OUR

We decided to sell
THE SUV →

And since we didn't have a car,
we didn't need a driveway.

We dreamed of replacing it with

WILD FLOWERS

"NO!"

But the CITY said

"It is ILLEGAL to GET RID OF YOUR DRIVEWAY IN NORTH YORK."

"YOUR DRIVEWAY **MUST** BE MADE OF CONCRETE, ASPHALT OR INTERLOCK."

"AND YOU CANNOT PLANT MORE THAN ONE TREE."

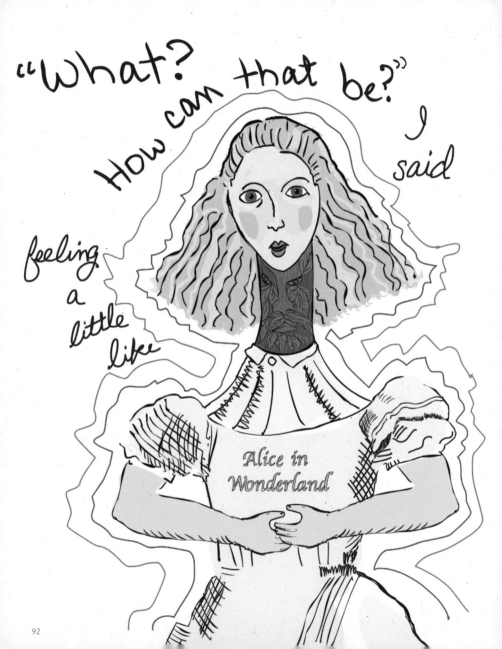

I don't know if it was the TORONTO STAR

Eco-friendly driveway is rejected by the city

Or Treehugger

Don't Rip Up Your Driveway in North York

Or bloggers. **Burner Trouble**
Water wars, oil wars, climate change

Franke James wants a green driveway, city says 'no'.

Or perhaps it
was the
CITY TV
interview?

OR MAYBE IT WAS JUST BECAUSE I PICKED UP THE PHONE AND SPOKE TO A NICE LADY IN THE MAYOR'S OFFICE WHO AGREED THAT

TORONTO-THE-GREEN SH<u>OU</u>LD LET US BUILD AN ECO-FRIENDLY DRIVEWAY – AND THE CITY WOULD BE PLEASED – BECAUSE THEY N<u>EVE</u>R THOUGHT PEOPLE WOULD RIP UP THEIR DRIVEWAYS TO HELP

THE ENVIRONMENT.

And so we got a permit for the 1st Green driveway in North YORK (which is really in Toronto).

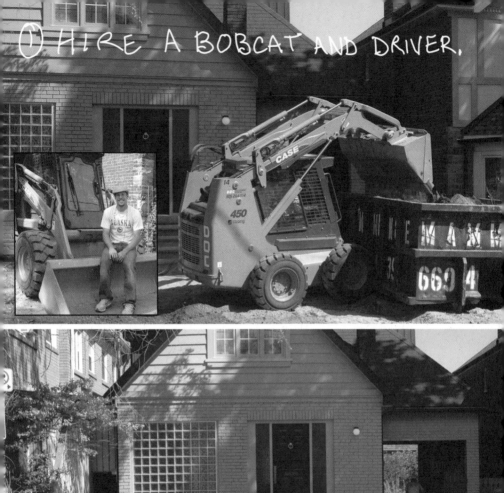

① HIRE A BOBCAT AND DRIVER.

② ORDER SOIL, SAND & GRAVEL.

96

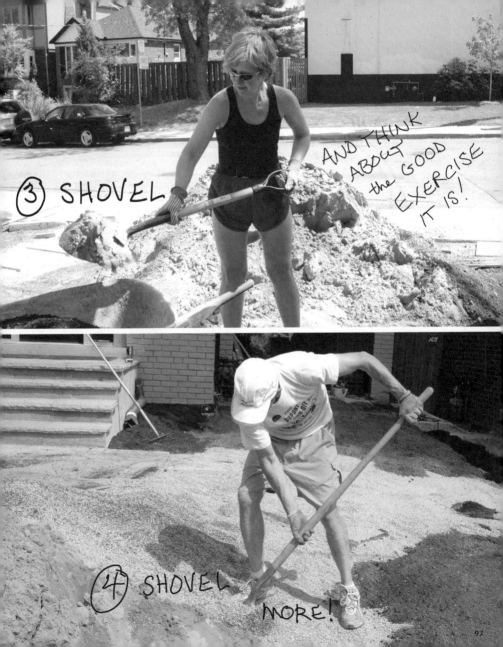

③ SHOVEL

AND THINK ABOUT the GOOD EXERCISE IT IS!

④ SHOVEL MORE!

97

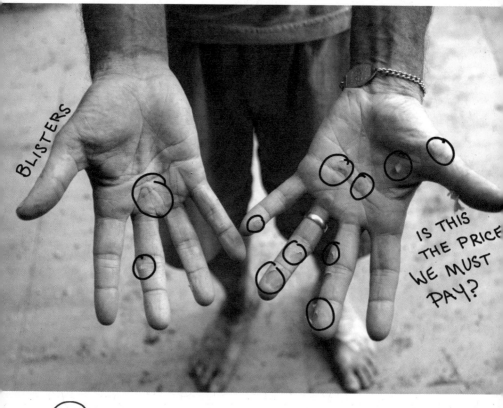

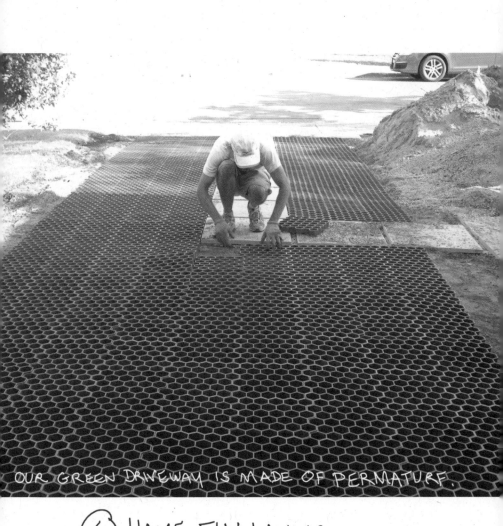

OUR GREEN DRIVEWAY IS MADE OF PERMATURF.

⑥ HAVE FUN LAYING
 OUT THE PAVERS.

(7) GET PLANTS DELIVERED.

(8) SPEND ALL DAY PLANTING

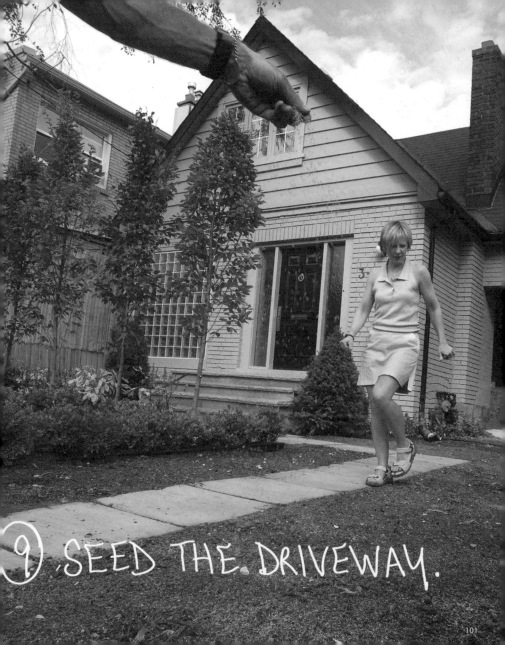

9. SEED THE DRIVEWAY.

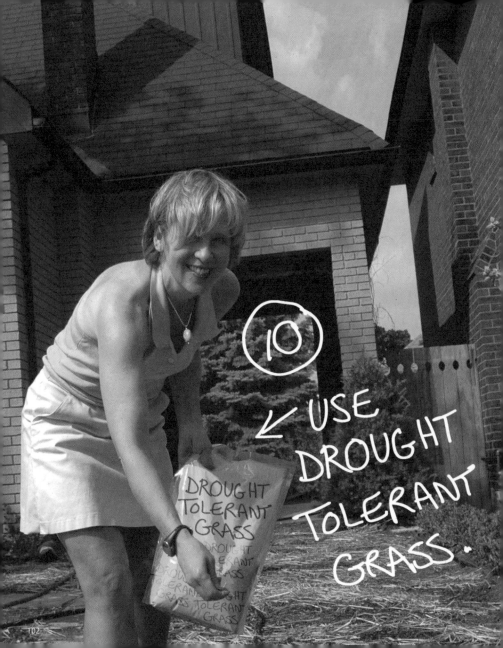

ONE YEAR LATER,
ENJOY THE FRUITS
OF OUR LABOR.

With the grass grown in the Permaturf is INVISIBLE. Which is just what we wanted.

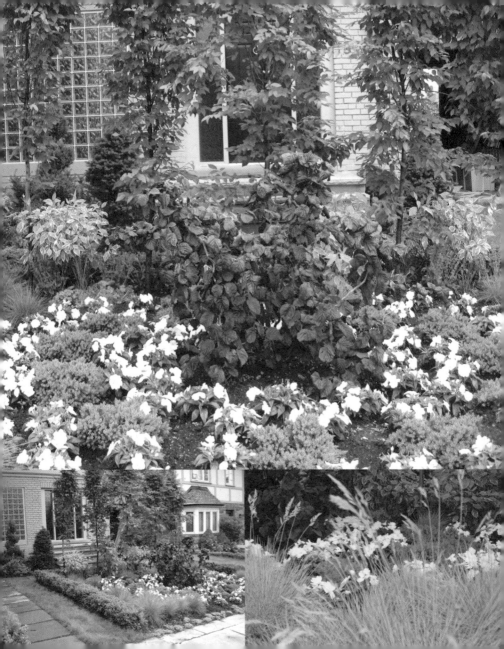

STORMWATER REPORT CARD

DUMP NO WASTE

DRAINS TO LAKE

So does a green driveway make a difference in rainwater running into the sewers?

YES!

A+

INTERLOCK DRIVEWAY

GREEN DRIVEWAY

12,838 GALLONS OF STORM WATER RAN INTO SEWERS

2,703 GALLONS OF STORMWATER RAN INTO SEWERS

10,135 GALLONS RECHARGED THE GROUNDWATER AND NOURISHED PLANTS AND TREES WITH OUR GREEN DRIVEWAY

* Our green driveway calculation is based on annual rainfall of 27 inches, and 20% runoff.

BEFORE
July 2007

Interlocking brick

Functional but ugly

Park 4 cars on it

Nuisance: Cars turning into our driveway

Heat island effect in summer

Barren and empty

Stormwater runoff went into sewers

Zero curb appeal

No trees or plants

Bad for environment

AFTER
July 2008

Green Driveway
Flower/Herb Garden

Functional and beautiful

Parking for 1 car

We're gardeners now!

Lush, green oasis

Great conversation-starter

Naturally cooled by trees

From zero trees to ten trees!

Rainwater goes into ground and feeds trees and plants

Lots of curb appeal

Good for environment

I think about JONI MITCHELL'S
SONG and I know she would
GET IT.

THEY PAVED PARADISE AND PUT UP A PARKING LOT WITH A PINK HOTEL.

We UNPAVED OUR PARADISE
and IT'S GORGEOUS!
CAN YOU UNPAVE
your paradise?

Chapter Five:
To My Future Grandkids in 2020

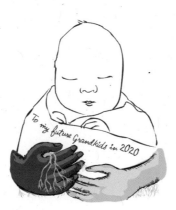

Why do I even think of you?
13 years into the Future? ~~NUTS~~

A child not even Born?

~~Funny~~ ~~NEVER~~

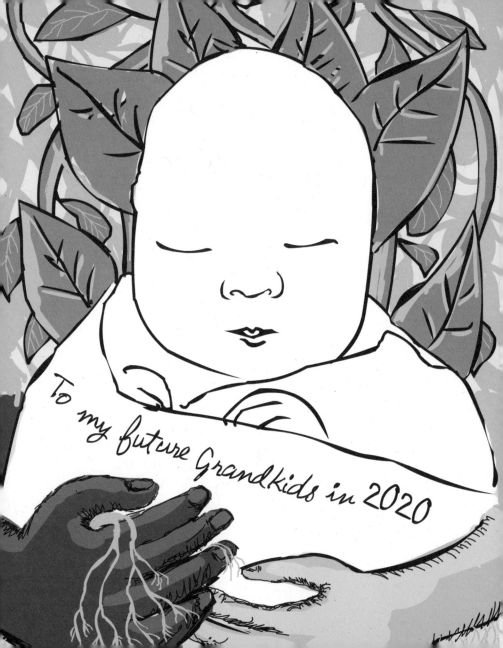

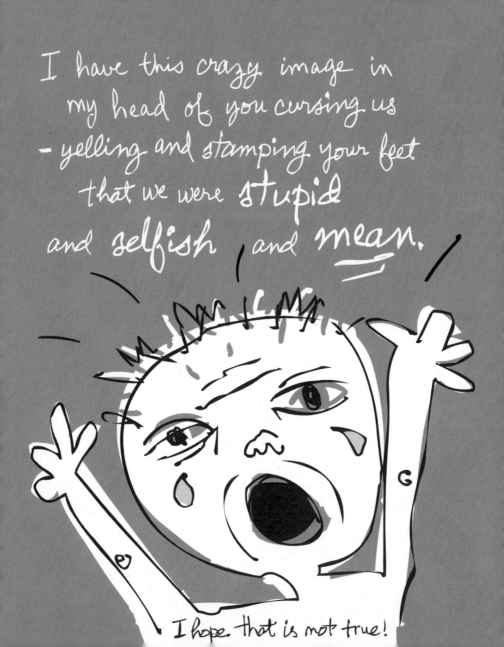

Every time I hear climate
forecasts of what LIFE may be like
in the future I think of you.

When I was a kid,
 Christmas was always WHITE...

Me→
Age 3
Using my
teeth to pull
up my mitten.

But now Christmas is GREEN with FAKE snowmen. The climate has already changed in our lifetime, and yet people RUN from that TRUTH.

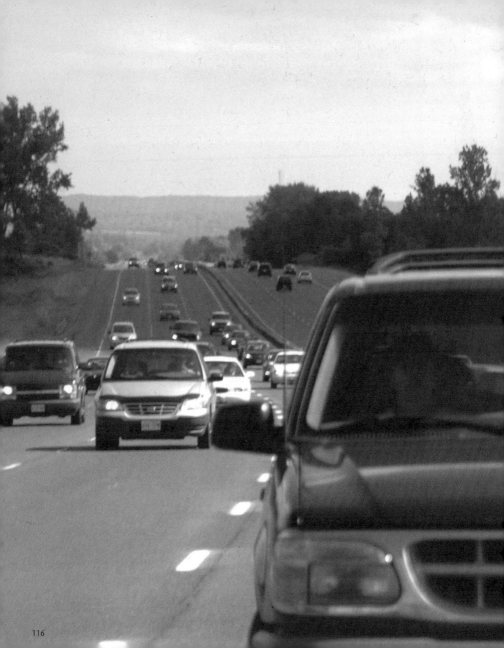

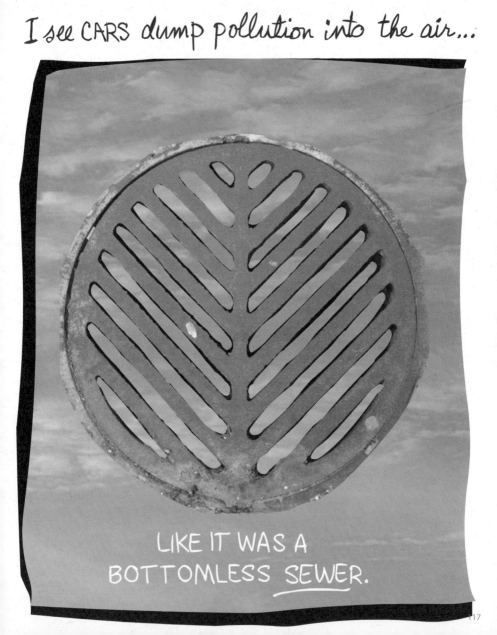

I see CARS dump pollution into the air...

LIKE IT WAS A
BOTTOMLESS SEWER.

117

The very next day, the news warned:

THE WORLD HAS 15-YEAR WINDOW TO CUT EMISSIONS

MY JAW DROPPED "15 YEARS!

THAT'S GOING TO AFFECT YOU — AND ME."

The world will have to pay attention now, or else...

But people yawned and wrote
the warnings off as more...

DIRE
PREDICTIONS

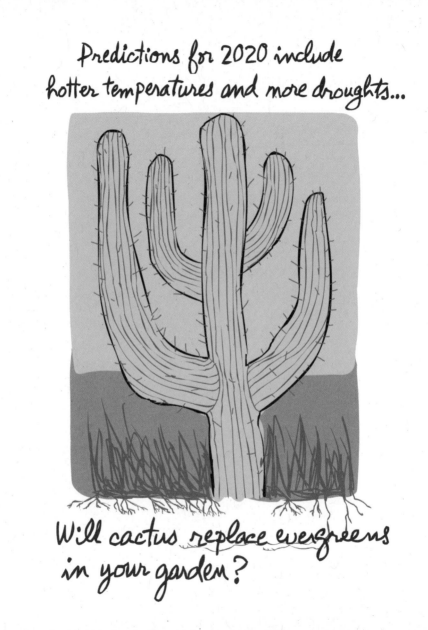

Predictions for 2020 include hotter temperatures and more droughts...

Will cactus replace evergreens in your garden?

I think about your water being RATIONED...

WILL YOU CALL US CRAZY FOR
FILLING UP SWIMMING POOLS WITH

DRINKING WATER

In the midst
of writing this
down for you,
I wonder,

"What does my family think?"

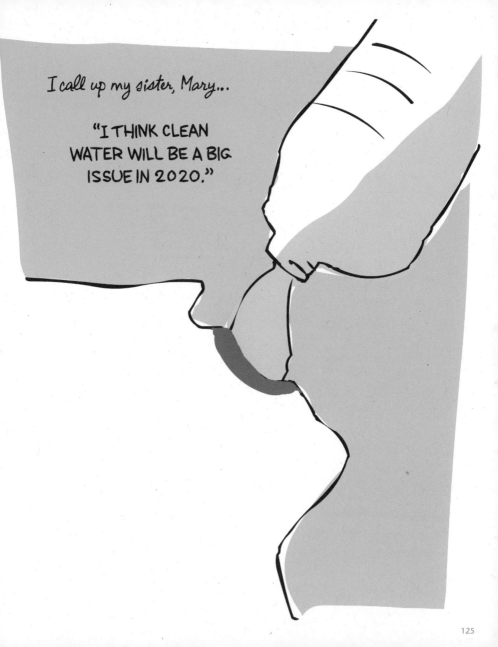

I ask my teenage daughter (Aunt or Mom to you!) if she thinks global warming will impact us by 2020...

Bronwyn says, "Global warming doesn't keep me up at night! But I am worried that the summers are going to be disgusting, because they already are."

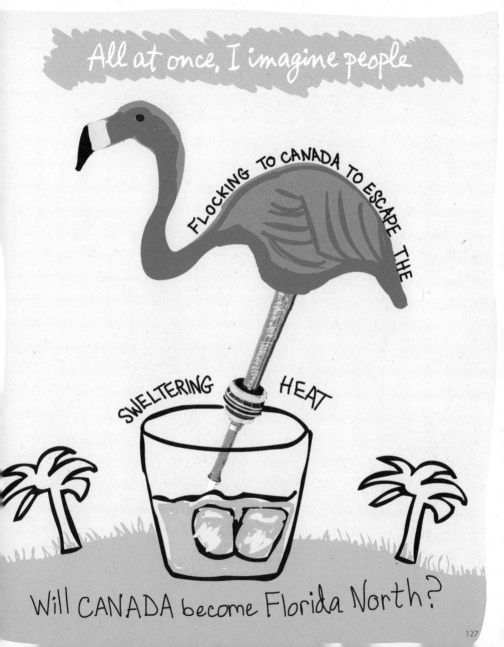

All at once, I imagine people

FLOCKING TO CANADA TO ESCAPE THE

SWELTERING HEAT

Will CANADA become Florida North?

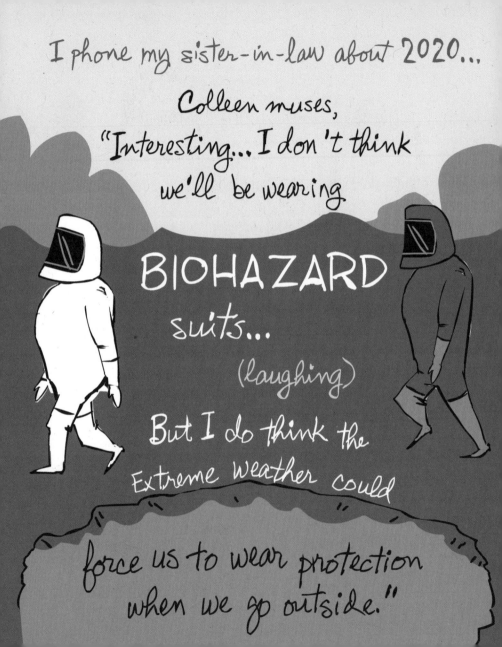

"Of course your brother won't notice because he's a cave-DWELLER."

I'm on a ROLL...
I call my sister Margaret
about this Grandma letter.
But she just says,

"GRANDCHILDREN?
WHAT GRANDCHILDREN?

OUR KIDS ARE 30
AND THEY'RE STILL NOT
HAVING KIDS!

I'M MORE WORRIED
ABOUT THE BEES DYING.

AND THE
BIRDS GETTING
WIPED OUT
BY WEST NILE."

And I had to agree that the BIRDS 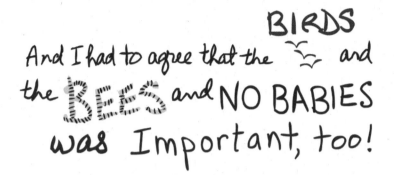 and the BEES and NO BABIES was Important, too!

But I was hoping for a great insight...
So, I call my Dad (your Great Grandfather).
He always nails down issues...

"Global warming is certainly THE challenge
for your generation. Just like World War II
was for ours... I'm sure you'll find ways
to deal with it."

The CHALLENGE for our generation?

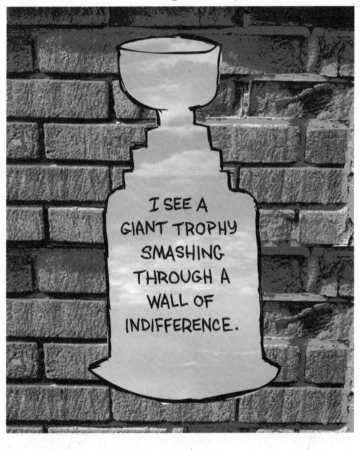

Would the world compete for a Climate Change Cup? If you could bet 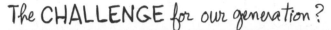 on it.

But the bumper-to-bumper traffic,

outside our door, makes me think...

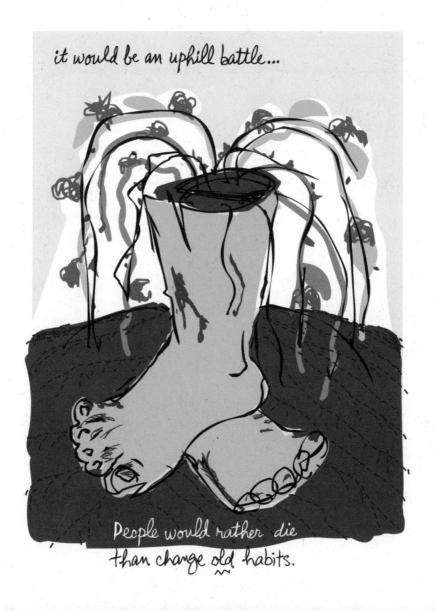

it would be an uphill battle...

People would rather die
than change old habits.

HINDSIGHT IS 2020

Sometimes I imagine it is 2020, and I look back at what we could have done differently.

And I'm sure you'll think we had

"But really... People won't get away with polluting. It will be as bad as...

DRUNK DRIVING OR

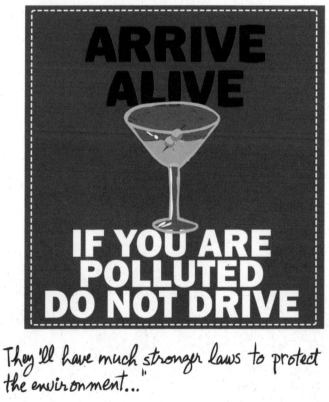

ARRIVE ALIVE

IF YOU ARE POLLUTED DO NOT DRIVE

They'll have much stronger laws to protect the environment..."

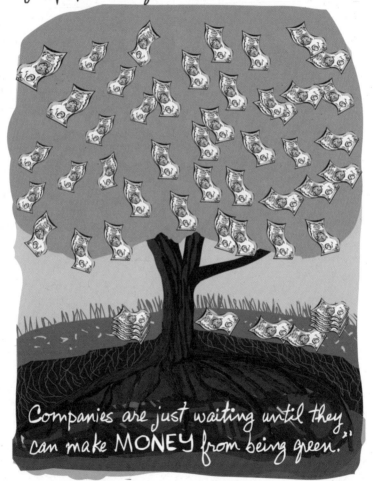

To my future Grandkids in 2020

Maybe David is right, and companies will step up to solve the problem. And maybe Margaret is right that the birds and the bees are a key to our survival...

The funny thing is... You know the ending to this story and I don't! Perhaps that's better...

I want to think that we're going to beat this. With enough brains, willpower and money we can do it. But whatever happens — you'll know I tried my BEST for you.

All my love,
Grandma

Reactions to:
Bothered by My Green Conscience

"Franke James totally gets it! GREEN and GROOVY are not mutually exclusive. Glamorous eccentrics care about the planet... They care about the stage upon which they sizzle and shine!" **Simon Doonan, author of** *Eccentric Glamour*

"I love the reactions of ordinary people to Franke James' idea of selling her SUV. Love Suzuki the uber-environmentalist. Love that Franke has a beer fridge and that she is not perfect in this green stuff and that Suzuki would find a lot to criticize... *My SUV and Me Say Goodbye* shows that the imperfect person can still contribute a lot because people don't have to be environmental purists in order to make a difference." **Claire Bernstein, You! Be the Judge**

"In her quest to wake up people to climate change, Franke James uses whimsical collages of words and images that bite you under the surface and tease your values. She isn't afraid to take on anyone, from big industry to the cultural icons who try to make global warming an intellectual game. When my co-editor, Kim Blank, and I decided to edit a book of cultural readings for university students, we knew that we wanted James and Rachel Carson to anchor the conclusion." **Stephen Eaton Hume, author of** *Economics Writing*

"Franke James' *Bothered by My Green Conscience* contains powerful visual essays. As a university professor who has taught environmental engineering for almost twenty years, I find that the messages are especially clear, complemented with excellent research. The weaving of a self-deprecating personal journey with ecological principles is brilliant. Her visual essay style is a treat for the mind. Franke's stories will help the rest of us be less fearful of making changes in our everyday lives." **Alex Mayer, Ph.D., Center for Water & Society, Michigan Technological University**

"Franke James uses right-brain thinking and a unique visual style to green her future, and ours. She fuses together the conflicting ideas around her personal lifestyle and her concern about climate change and arrives at some novel solutions. *Bothered by My Green Conscience* leaves an imprint. Fantastic!" **Daniel H. Pink, author of *A Whole New Mind***

"Franke James likes doing the hard things first, which is why, when it came to reducing her carbon footprint, she skipped right past the programmable thermostat and coffee thermos business and headed straight for the real green challenge – selling her SUV and replacing the driveway with a garden. Well, technically speaking, the driveway still exists. But it's been completely covered in grass and surrounded with trees, bushes and other lush foliage." **Vanessa Farquharson, National Post**

"Franke made it for her unborn grandchildren but I think it is for all of us. Franke James is a genius and we have rocks in our heads. I can't add any more to this because it is perfect."
Martin Edic, BurnerTrouble.com

"Wowzers! This is FANTASTIC. Franke's visual essay clearly articulates the risks of NOT acting. Policy analysts struggle to convey what *My Green Conscience* has so clearly expressed."
Eli van der Giessen, David Suzuki Foundation

"Toronto artist Franke James exemplifies the artists' ability to persuade in a series of beautiful and powerful visual essays on environmental topics... Franke has a very personal and thoughtful take which brings home some of the dry and terrible facts of climate change. Highly recommended."
Stephen Leahy, International Environmental Journalist

"What first drew me to Franke's work was a piece born from her attendance at a discussion between Malcolm Gladwell and Mark Kingwell... It's a fascinating take on two great thinkers... Franke says, "As artists we can hold up a mirror that reflects back society's values — even if that sometimes makes people uncomfortable." Uncomfortable? Perhaps. But unique, beautiful and thought-provoking along the way." **Michelle Riggen-Ransom, Poptech.org**

"*The Real Poop on Social Change* is a beautiful essay! Thanks for making hard thoughts so easy on the eye... I think sometimes change comes when the internal din of those questions becomes so intense that people are moved to action just to quiet them." **Liz Seymour, Social Activist and writer, N.C., USA**

"Franke James asks the questions all of us should be asking ourselves about our environmental responsibility. Her book is perfect for anyone overwhelmed by the implications of climate change and seeking to reduce their footprint. As a university student, I like her refreshing take on global warming and the way she tosses aside economic jargon to find ways we can help bring about change." **Nicola Sharp, Economics student, University of Victoria**

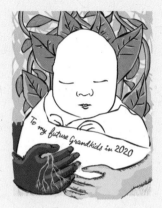

"Franke James has done it again. Right on! My big thing is intergenerational equity. Thinking like an ancestor! Why does our generation think we've got the right to "have it all" today by taking so much away from future generations? Where did this society-wide narcissism come from? Franke and her thoughtful visual essays indeed exemplify the heart and the art of making a difference for the sake of the future." **Julie Johnston, GreenHeart Education**

"We were previously wowed by Franke James' illustrated essay on global warming. Clearly she is taking the issue seriously, for after much illustrated soul-searching, she has sold her SUV and gone car-less. Her new illustrated essay describes the reasoning and the reaction. I found it particularly interesting because it is counter-intuitive. We promote Compact Fluorescents because we think of them as first steps, painless and cheap, doing the easiest things first. Franke suggests Doing the Hardest Thing First, which for her is giving up the car. She lives near a subway and shopping but it is a lot tougher than changing a light bulb. And the change in her life that results is a lot more significant." **Lloyd Alter, Treehugger.com**

"My SUV and Me Say Goodbye is an amazing visual essay. I picked up my Prius a few days ago. Every time I go somewhere, I feel happy knowing that I am using less gas then I would be using my former Audi. Being green does not mean you need to be deprived. There is a joy that arises when we live in alignment with the planet." **Arnie Herz, Lawyer and author of LegalSanity.com**

Paradise Unpaved: Franke James' Driveway One Year Later. "A year ago we recounted how artist Franke James gave up her SUV and then decided to rip up her driveway, except the law said that every house had to have a driveway paved with concrete, asphalt or brick. Even porous pavers like turfstone were illegal. Franke took her case (and a printout of TreeHugger) to City Hall and won; now she tells her story in her wonderful mix of humor, drawing and photography." **Lloyd Alter, Treehugger.com**

"Thanks for taking that huge first step and for not taking 'No' for an answer from the City of Toronto. You demonstrate that change may surprise us by being more fulfilling than maintaining the status quo. So many of us want to do something substantive... Thanks for showing us the way." **Joan Chadde, President, Michigan Alliance for Environmental & Outdoor Education**

"Like the White Rabbit in Alice in Wonderland, we are 'late for a very important date' with the truth about our planet and the shallow assumptions that have distorted our respect for its well being. In five lucid visual essays, Franke James chronicles her adventures in our absurd world of do nothing complacency and ever accelerating political spin." **Tom Sagar, Newmarket, Ontario, Canada**

"Can you fight City Hall? A wonderfully inspiring story how a North York artist turned her four-car parking pad into a garden, notwithstanding municipal requirements for a paved driveway. Franke James eventually got Toronto's first permit for a "green" driveway, and estimates that she has already kept 10,135 gallons of stormwater out of the sewers." **Dianne Saxe, Ph.D. in Law, Specialist in Environmental Law**

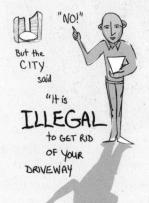

Saving the Earth - One Driveway at a Time: "Paradise Unpaved by Franke James is beautiful, engaging, funny, inspiring, and practical. It's the story of how my friend and colleague Franke James and her husband successfully went up against the city of North York (which, as she points out, is really Toronto) to be allowed to replace their huge, ugly, ecologically unsound concrete interlock driveway with a green alternative. She also has a number of other really excellent visual essays on the environment... All in all, Franke is a huge net gain for the planet!" **Erika Andersen, author of *Being Strategic***

"What I have learned is that people do not change the way they do things unless they see how it will touch them personally. Bringing something so big and overwhelming and far off (we think) in the future into the present is very hard to get one's head around. Franke James makes climate change personal... The things that we do to 'control' the world around us needs to stop so that there will be a world around for our grandchildren... Let's make their survival our reason to change! Thanks Franke for continuing to nudge us in that direction!" **Mary-Martha Hale, Executive Director, Centre 454, Ottawa, Canada**

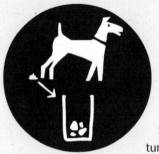

"Love your 'Grandma 2020' essay — read it before I went to bed and woke up still thinking about it. Thanks for the nudge, Franke. I can't make the city stop trucking my garbage 800KM to Michigan but I can make sure that my contribution to the trip is as small as possible. I can't make the federal government adhere to the Kyoto accord, but I can put on a sweater instead of turning the heat up. Every day we all make a hundred little decisions as we make our way in the world. If everyone made each of these decisions with the idea firmly in mind that we must do what we can to leave the best possible planet for our grandkids, we could do what the governments seem unable to do — turn the tide. 'Cause if we don't, our grandkids are going to be cursing us — and we will deserve it." **Lindsay Barker, Toronto, Canada**

"I bumped into Franke James recently on Twitter and have since discovered her marvelous visual essays. I'm a visual thinker myself, and Franke's approach strikes a real chord with me. Her style of art and re-visioning of photographs pulls me in with effective (and affective) imagery that lingers long after viewing — key elements for any successful story." **Dave Riddell, Environment & Sustainable Development Research Centre, University of New Brunswick**

"Genius, brilliant... *Bothered by My Green Conscience* is a live capture of the big and small everyday crises we all face in trying to live with integrity in a complicated world." **David Ticoll, author of *The Naked Corporation***

"I continue to be amazed at your ability to put into such simple, compelling 'language' what needs to be said. Keep up the fabulous work." **Mary Ann Grainger, CEO, Toronto Danforth Federal Green Party Association**

"Atmospheric CO_2 is well above safe levels of 350 parts per million, and signs of climate change are all around us. We're just years away from the point when scientists begin counting the number of days that the Arctic Ocean is ice free each summer. Should we bury our heads in the sand like an ostrich? Or, should we press on like artist Franke James with her eyes wide open and heart fully engaged with the people and world around her? I say, "The latter!" *Bothered by My Green Conscience* is a rare work of emotional leadership that can help people choose to get moving in the right direction, page after beautiful page." **Michael McGee, Founder of CO2Now.org**

"OK, Franke. You've just instilled a TON of guilt over our 3 SUVs (actually, we'll be downsizing to 2 very soon as soon as we sell the Jeep, but still...). This is yet another wonderful visual essay. I love the way you put such a human side to global warming and our role in responding to it... but you don't strike me as a granola-loving tree hugger." **Timothy Johnson, author of *GUST*.**

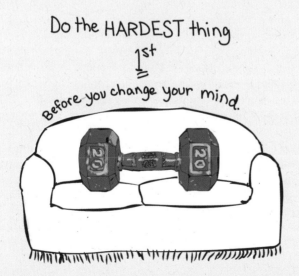

Acknowledgments

There are many people to thank for the creation of this book, but the person at the top of the list has to be **Heather Nicholas**, Online Editor at New Society Publishers who left this note on my site in August 2007, "*This is fantastic! My friend at the next desk over is laughing out loud right now as she reads it. I have blogged about your essay here...*" Shortly thereafter, Heather contacted me wondering if I might be interested in publishing my visual essays. I am happy to say that the experience of working with New Society has been amazing. It's not many publishers who will entrust an author with the responsibility of writing *and* designing a book and for that I am very grateful and count myself lucky. Please take a bow: **Chris Plant, Ginny Miller, EJ Hurst, Sue Custance, Greg Green, Ingrid Witvoet**, and **Diane McIntosh**.

Encouragement to an artist is like water to a plant – and thankfully I have been well hydrated. My thanks to **Kim Blank** and **Stephen Hume** at University of Victoria who spotted my first visual essay, *A Green Winter*, and included it in their anthology. Thanks to **Lloyd Alter**, at Treehugger, for making me laugh that doing the hardest thing first is "*particularly interesting because it is counter-intuitive.*" Thanks to **Joan Chadde** and **Alex Mayer** at Michigan Technological University for teaching me how to calculate the stormwater diverted by our green driveway! Thanks to **Manifest Communications** for hosting the *Well/Well* event that inspired the *Real Poop on Social Change* essay. Thanks to artist **Christa Gampp** for her exquisite *Chest of Hope* sculpture on page 56. Thanks to **Rene Boutin** and **Steve Whitehouse** for their help with the *HazMat* character, which I have recycled to humorous advantage, on pages 128 & 129. And to everyone who provided comments on how my work spoke to them – I am very grateful. Thank you for your thoughtfulness.

Finally, and most importantly, I want to thank my husband, and soulmate, **Bill James** for all his love and support, and for going along on this wonderful green adventure. How many husbands would agree to rip up an interlocking brick driveway? And replace it with a green driveway built with their own two hands? I am very fortunate.

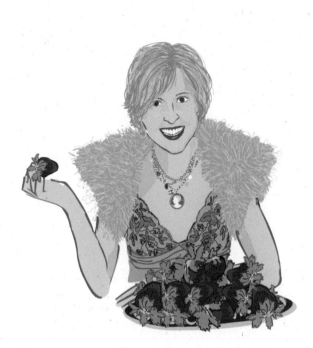

About: **Franke James**

Franke James is an artist and writer who enjoys the wonderful, thrifty greenness and physical fitness that comes from being "car-free". She loves rediscovering eccentric glamour in her closet (but has not yet given away all her ordinary clothes). Franke is very glad she won the right to build the first green driveway in her city. Her green conscience still bothers her, but she recognizes that going green is a personal evolution that takes time (and she's not ready to give up imported strawberries, yet).

Franke has a Masters Degree in Fine Arts from University of Victoria, and a Bachelor of Fine Arts from Mount Allison University. She lives in Toronto, Canada and walks, or takes public transit most places.

Visit www.MyGreenConscience.com for more information.

What's bothering
your green conscience?

NEW SOCIETY PUBLISHERS

ENVIRONMENTAL BENEFITS STATEMENT

New Society Publishers saved the following resources by printing the pages of this book on chlorine free paper made with 100% post-consumer waste.

TREES	WATER	ENERGY	SOLID WASTE	GREENHOUSE GASES
32	**11,787**	**23**	**1,514**	**2,840**
FULLY GROWN	GALLONS	MILLION BTUs	POUNDS	POUNDS

Calculations based on research by Environmental Defense and the Paper Task Force. Printed and bound in Canada by Friesens Corporation.

NEW SOCIETY PUBLISHERS

For a full list of NSP's titles, please call 1-800-567-6772
or check out our website at: www.newsociety.com